ABELARDO MORELL

ABELARDO MORELL

Face to Face:
Photographs at the Gardner Museum

Charles Simic Jennifer R. Gross Introduction by Jill S. Medvedow

ISABELLA STEWART GARDNER MUSEUM

Boston, Massachusetts

✣

This book is published in conjunction with the exhibition
"Abelardo Morell, Face to Face: Photographs at the Gardner
Museum," September 18, 1998–January 3, 1999, at the Isabella
Stewart Gardner Museum, Boston.

Published by the Trustees of the Isabella Stewart Gardner Museum
Two Palace Road, Boston, Massachusetts 02115

Photographs are courtesy of Bonni Benrubi Gallery,
New York, New York.
All images are gelatin silver prints measuring 20 x 24 inches
or 24 x 20 inches.

Cover: *Tim and Rembrandt, Gardner Museum, 1998*
Designer: Ruth Abrahams
Typeface: Joanna
Printer: Meridian Printing, East Greenwich, Rhode Island

Distributed by University Press of New England,
Hanover and London

Major support for this exhibition, publication, and residency have been provided by
the National Endowment for the Arts, a Federal agency; the Lannan Foundation;
and the LEF Foundation.

Sponsorship of artist programming is made possible by the Barbara Lee Program
Fund. Major support for "Eye of the Beholder" programs has been provided by The
Pew Charitable Trusts, the Stratford Foundation, The Boston Foundation, GTE, and
the Clipper Ship Foundation.

A portion of the Museum's operating funds for programming this fiscal year has
also been provided through grants from the Institute of Museum and Library
Services, a Federal agency, and the Massachusetts Cultural Council, a state agency
that also receives support from the National Endowment for the Arts.

Library of Congress Cataloging-in-Publication Data

Morell, Abelardo
 Abelardo Morell, face to face : photographs at the Gardner
 Museum / Charles Simic, Jennifer R. Gross : introduction by
 Jill S. Medvedow
 p. cm.
 "Published in conjunction with the exhibition 'Abelardo Morell,
 face to face: photographs at the Gardner Museum', September 18,
 1998–January 3, 1999, at the Isabella Stewart Gardner Museum,
 Boston"--CIP galley.
 ISBN 0-9648475-8-2 (pbk.)
 1. Photography, Artistic--Exhibitions. 2. Morell, Abelardo--
Exhibitions. 3. Photography of art--Exhibitions. I. Simic,
Charles, 1938– . II. Gross, Jennifer R. III. Isabella Stewart
Gardner Museum. IV. Title.
TR647.M66 1998
779'.092--dc21 98-28411
 CIP

THIS PROJECT IS FUNDED IN PART BY THE
MASSACHUSETTS CULTURAL COUNCIL

CONTENTS

FOREWORD

The art at the Gardner had a big effect on the photographs I have made inside this Museum. But it was not the art on its own that influenced me. It was the relationship of these art objects to the rooms where they hang and to the people who care for and protect them that inspired much of the work I did during this residency. It was a privilege and a pleasure to spend time wandering through the Museum at all kinds of hours. I think that what I discovered in these strolls is a dynamic collection made up of sculptures, guards, gardeners, sunlight, conservators, maintenance people, rooms, and paintings that, from a certain angle, may be seen talking to one another. I hope that my own pictures speak to these relationships.

The work that I did at the Gardner would not have been possible without the help and guidance of many people. I am thankful to Jennifer Gross for her humane intelligence and good humor, which she showed throughout this project. Her editorial advice was also invaluable. I am grateful to Jill Medvedow for her invitation to be at the Museum and to Anne Hawley for reviving Isabella Stewart Gardner's commitment to contemporary artists. I am honored by Charles Simic's essay, which is full of poetry and love for photography.

Mimi Pomeranz's faithful attention to details gracefully smoothed my way into the collection. I greatly appreciate Corey Davis's technical and logistical help in making the photographs. His advice often made for better pictures. Hilliard Goldfarb's insight into the collection brought Isabella Stewart Gardner's Museum into a new light. Patrick McMahon and Lowell Bassett were helpful with archival research.

Tim Allen, David Foster, Ryan Grover, Joan Hallaren, and Ed Kozak were patient and generous in posing for my camera. They represent the working spirit of the whole staff at the Gardner for which I am very thankful. Finally, I am most grateful to Isabella Stewart Gardner, whose Museum reframed the way I look at art.

Abelardo Morell

PREFACE

The Gardner Museum, through our Artists-in-Residence program and our Music program, is committed to supporting and presenting new work by living artists. By doing this we honor not only the legacy of artists' matronage by the Museum's founder, but we carry forward the essential civic role of supporting the creative imagination, the life of the mind, and connecting this work to our publics.

In the United States, where the dominant culture is one of evanescent entertainment that frequently anesthetizes the mind of the public, it is important for the Museum to support artists and bring their work to the public to engage viewers in wondering about life and all its complex dimensions, joys, and struggles.

The Museum is grateful to all those who made this exhibition —and Abelardo Morell's residency—possible. First, our thank-yous go to the artist, Abelardo Morell, whose bravery and courageousness enable him to wake up every day and go about the task of making work from his imagination. Abelardo is a member of the Boston community, living, working, and teaching here. He is a professor of photography at the venerable Massachusetts College of Art. His work has been exhibited around this country, from the Museum of Modern Art in New York to the Museum of Photographic Arts in San Diego, where a mid-career retrospective opens in late 1998. His work has also been exhibited internationally, from Korea and Japan to Israel.

Special thanks to Hilliard Goldfarb, chief curator of collections at the Museum, who brought Abelardo Morell to Jill Medvedow's attention. The Museum is grateful to Jill Medvedow (now the director of the Institute of Contemporary Art in Boston), who conceived of this residency while she was the curator of contemporary art and deputy director of programs at the Gardner and has graciously written the introduction to this publication. The Museum staff has been energized by Abelardo Morell's presence, and the Museum thanks Jennifer R. Gross, curator of contemporary art and public programming, for curating the exhibition and residency, and Mimi Pomeranz, public programs coordinator, for enabling Abelardo's work and presence in the Museum. Special thanks go also to Karen Croff Bates, associate director of public programs and curator of education; Gretchen Dietrich, assistant curator of education, and Linda Graetz, director of curriculum and instruction, for their commitment to realizing excellence in exhibition-related education programs; and to the teachers, students, and administrators who are our school partners in these education programs.

Thank you to Patrick McMahon, registrar and assistant to the chief curator, and to Lowell Bassett, collections assistant, for access to the archives and for consistently bringing points of interest in the galleries into focus for the Museum's resident artists and "Eye of the Beholder" lecturers. Abelardo could not have done his work without the help of his more-than-able assistant Corey Davis. We want also to thank the Museum's Security staff for making all things possible at all times, and the Conservation staff for their patient attention to the many questions pertaining to this project and their encouragement of all Abelardo Morell's undertakings. Thanks, too, to Chris Aldrich, preparator; Ruth Abrahams, designer; and to the Museum's Program Committee, chaired by Barbara Lee and whose members include trustees Frieda Garcia, Beth McNay, Marcia Radosevich, and Charles Wood and overseers Sheryl Foti-Straus, Vivien Hassenfeld, Barbara Jordan, and David Scudder.

Finally, it is not possible to do our work without funding. The National Endowment for the Arts, the Lannan Foundation, and the LEF Foundation provided direct funding for this program. Artist programming and education initiatives related to it have also received support from the following in 1998: Barbara Lee Program Fund, The Pew Charitable Trusts, the Stratford Foundation, The Boston Foundation, GTE, and the Clipper Ship Foundation. To them, for enabling Abelardo Morell's work and the Museum's artists and education programs, we are all most grateful.

Anne Hawley
Director

INTRODUCTION

Abelardo Morell takes photographs of the familiar. His images are not manipulated by computer, handpainted, or even in color. He uses simple photographic devices such as long or double exposures, superimposition, perspective, and composition to narrow and expand ideas of time, scale, and meaning. And, with the economy of a poet, Morell has composed photographs of concrete images and details, using focus and juxtaposition to move backward and forward in time and history.

Abelardo Morell has described his photographs as "containers of drama." And like Charles Simic, who shares an interest in Abelardo's work and in photography and graciously agreed to write an essay for this catalog, Morell looks at the commonplace around him and infuses it with wonder. This theme, an awe of the ordinary, captures much of the trajectory of photography in the twentieth century.

I was first tempted by the idea of inviting Abe Morell to be an artist in residence at the Isabella Stewart Gardner Museum after seeing his close-up photographs of an open volume of engravings by Piranesi. The architectural details of Piranesi's coliseums and pyramids seemed mysterious, disorienting, infinite in these photographs. For a quick moment, the ink on the page as it curves into the book's gutter resembled a Chinese waterfall. Then the landscape became clear, and I could navigate the photograph and find myself in its distorted perspective.

Morell's "camera obscuras" also distort the obvious. Ordinary rooms are transformed into complex, ambiguous images. In one photograph, the Empire State Building looms upside down in a New York hotel room, turning the unremarkable into a scene both eerie and familiar. In another photograph, the childhood room of Morell's son Brady is invaded by the inverted image of the trees and rooftops outside, combining interior and exterior views in a way ordinarily not seen by our human eyes.

Bringing an artist into a historical museum, into a collection of immutable objects and installations, is another way of infusing the familiar and the fixed with the unseen and the imagined. Like many of his contemporaries, Abelardo Morell has gone inside the museum establishment, challenging time-honored perspectives and hierarchies by seeing them through a new lens.

In residence at the Gardner on and off for over a year, Morell has produced a series of new pairings and ambiguities. In one striking photograph, Rembrandt's jaunty, self-possessed portrait of himself as a young man cedes the foreground to an equally confident contemporary—a Museum maintenance man. Two intense, penetrating stares—separated by centuries, yet sharing one picture frame—ask the same questions, "What is that man thinking? About himself? About his world?"

"In the open fields of American experience, as catalogued with passion by Whitman and as sized up with a shrug by Warhol, everybody is a celebrity," Susan Sontag pointed out in *On Photography* (1973); and she continued, "No moment is more important than any other moment; no person is more interesting than any other person." In his paired portraits from the Gardner, Abelardo Morell illustrates just this truth.

I am very grateful to Abe for turning his eye, and his particular brand of bifocal vision, to the Gardner Museum. His unique way of combining the past and the present is well suited to the Gardner's dramatic contrast among the old master works of art, architecture, and decorative arts. Whether he is capturing an image of water dripping, a child's room, a member of the Museum's staff, or an open book, Abe Morell performs a quiet magic with his photographs, changing ordinary moments into extraordinary worlds. Rembrandt will never look the same.

Jill S. Medvedow
Director, The Institute of Contemporary Art
Boston

ABELARDO MORELL'S POETRY OF APPEARANCES

Like a slide show of dimly remembered, long-unvisited scenes of our lives projected on the wall of a large bedroom languidly crisscrossed by shadows. Half-lit faces and objects made even more strange by their recognizability in the midst of much that remains blurred and fragmented. That uneasy feeling of being uncertain whether I'm dreaming or lying sleepless. My own room, which I suddenly do not know, its darkness shimmering nebulously as if its walls and ceiling were covered with mirrors. An insomniac's secret collection of grainy, black-and-white images that flicker on and off, mystifying in their randomness, in their scrambling of the familiar and the unknown.

We have all awakened in a hotel room or a friend's house after deep sleep not knowing who we are, disoriented about the time and the place, watching the light slip between the drawn curtains to examine a pair of dust balls on the bare floor or woo something we cannot see on the table. Here's the poetry of the overlooked and invisible dailiness. A framed photograph of the New York skyline no one has looked at closely in ages, a sphinxlike armchair, a Gideon's Bible perused solely by book lice, an unretrieved button, a pencil stub, a penny secreted under a dresser or in a shadowy corner, and a menagerie of water stains caged on the high ceiling. The realm of memory is a hotel room sewing kit open in my hands. I sit naked in the silence of this unknown room drawing a red thread through the eye of a needle. "It is not seeing—hearing—feeling," the eighteenth-century German poet Novalis wrote, "it is the combination of all three—more than all three—a sensation of immediate certainty—a view of my truest, most actual (psychic) life." This is what I wish to sew together here.

But how? The moment I begin to explain in detail what I have seen and felt, I run into difficulties. Our strangest dreams, as everybody knows, can never be fully told. Our afternoon daydreams with their play of ephemera are even harder to convey in their elusiveness. As long as we keep our mouths shut, all the nuances of sight and feeling appear in place. It is that very impossibility of describing them that is responsible for the lasting impression they make

on us. The world as we have never seen it before in its unreality lasts only as long as our silence does.

The same can be said of the experience of viewing a photograph. As long as we need only to point it out to someone without a comment, the way a small child does or a weary museumgoer, and expect merely a nod of agreement in return, innocence reigns. Language fails us as much as it empowers us. What is perceived and what is said rarely match. We approximate, we invent, we seek the

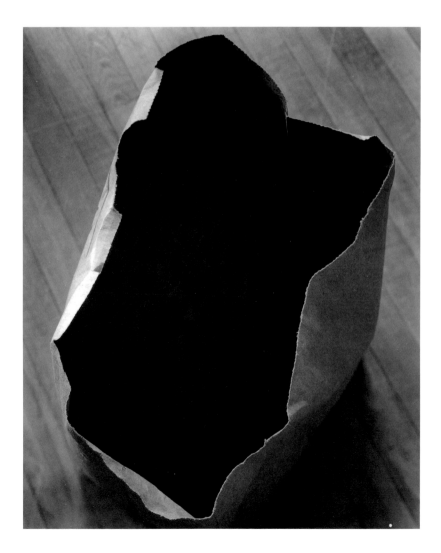

help of metaphors and similes to close the gap. That's why poems get revised and the history of philosophy is three thousand years old. When it comes to immediacy of being, the best words can do is to make a pact with a demon of analogy.

"Such is the photograph, it cannot *say* what it lets us see," wrote the French critic Roland Barthes. Still, the silence of the image, the obscurity of language, and the clarity of objects invite a dialogue. I talk back to them. I'm their ventriloquist. I want to make the photographs of Abelardo Morell speak back to me loudly enough so you, too, reader, can overhear our conversation.

‡ ‡ ‡

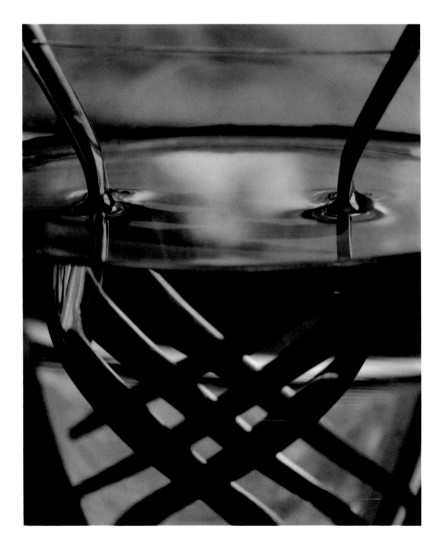

I turn your picture every which way, but you still find a way to look elsewhere and so with a calm and almost deliberate intention.
 —Franz Kafka, from a letter to Felice Bauer
 (translated 1973)

It compels me to look at it again—this is how I define the peculiarity of a memorable photograph. Something in it has become a trap for my imagination. I'm caught between what I see and that which I cannot see, but suspect may be there. It's as if I had suddenly become even more nearsighted than I actually am. I need to squint and close my eyes and open them again. Even a photograph of a blank wall without any scratches is an invitation to enter a labyrinth and promptly be lost. Let me give an example.

It occurred to me the other day that the way I look at a photograph today and respond to its imagery is tied to my first distinct memory of lingering over a photograph. I was not much older than six or seven. One Sunday, in German-occupied Belgrade, I went to visit my great aunt, an old, retired schoolteacher who lived in an apartment cluttered with furniture and paintings of several generations of dead relatives. To occupy me, I was provided with a thick photo album, but first, I remember, I had to wash my hands thoroughly, not once, but twice, after they failed to pass her inspection. That made me take extreme care with the album and pay close attention to every picture.

There were hundreds of them. Unknown men, women, and children in clothes of another era posing in their backyards and gardens, in front of some monument or an early model car, or in a few cases laid out in open coffins. Among the photographs, I came upon a sepia one that I can still see clearly. It is of a young teacher (my great aunt) standing in front of the blackboard of what looks like a village classroom, smiling faintly at a boy on the other side of the blackboard who is not much older than I was then and who is pointing at the sentence written on the board in large, ornate letters, so perfectly legible I have no difficulty reading it even today: SILENCE IS GOLDEN.

The boy appears ill at ease. His hair is cut so short, his head appears shaven. He wears a suit of a rough cloth that must have

made him itch and a white shirt open at the neck. It must have been a special occasion, the photographer making a rare visit to a remote village. Three other students with similarly cropped hair are visible

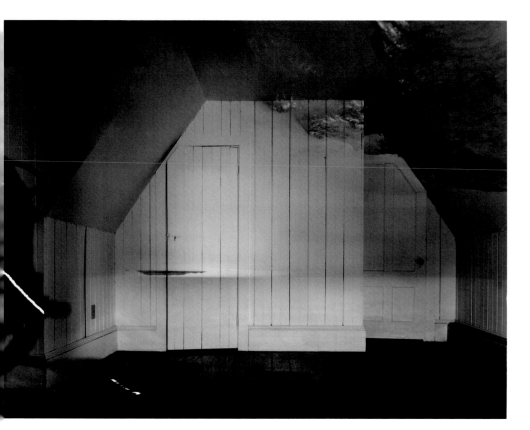

in the front seats, but their backs are to the camera. Although I cannot see their faces, I know their eyes are on the teacher and not on the charts and maps hanging on the wall to the side which, in any case, are blurred. On that same wall, there's also a window with black panes, giving the false impression that night had already fallen.

My aunt, who is seen in profile, wears a dark, Sunday-kind-of-dress and has her hair cut so it just barely covers her ears, causing her long, pale, muscular neck to stand out with determination. I immediately notice her resemblance to my father, who at the moment I'm studying the photograph is missing in the war, and that makes it very spooky.

For years, every time I called on my great aunt, I asked for the photo album so I could take another long look at the fading

photograph of that schoolroom. The enigma of "them" still standing there and of myself watching them seemed inexhaustible to me. Here was, in the words of the Italian painter Giorgio de Chirico, "a solemn sheet of paper witnessed by a moment and stamped by eternity." I have forgotten much in my life, but I can still visualize the small, white scar on the head of one of the students whose back is turned in the photograph. Against all probabilities, this unremarkable scene continues to enrich my imagination.

Moments far apart in time come together thanks to photographs. Someone's old reality becomes my new reality. How astonishing that is! After a while, the space of every closely observed photograph becomes an inhabited space. The real and the imaginary take turns exchanging identities. If there's an empty seat in the 1900s classroom, and there happens to be one, I find myself seated in it with my shoulders hunched and my face turned away from the camera. The same is true of many other powerful photographs in whose corners I've been hiding for years.

⁂ ⁂ ⁂

"It is important to see what is invisible to others," photographer Robert Frank maintains; and who could disagree? Morell stares at drops of water until he notices their resemblance to letters of the alphabet. There's an air of divination about his photographs. He wants the unseen to show itself, the marvelous to overtake us in the course of our daily lives.

How does Abelardo Morell go about doing that?

He turns a room, he tells us, into a camera obscura by covering its windows with black plastic so that the room is completely dark. Then he makes a 3/8-inch hole looking out at something interesting. Next, through this tiny opening, a fairly sharp, upside-down image of the outdoors appears on the opposite wall. After his eyes become accustomed to the dark, Morell gets his view camera and focuses on the projection on the wall. Chance and strict calculation combine to bring the images from outside into the room.

Camera Obscura Image of the Sea in Attic, 1994

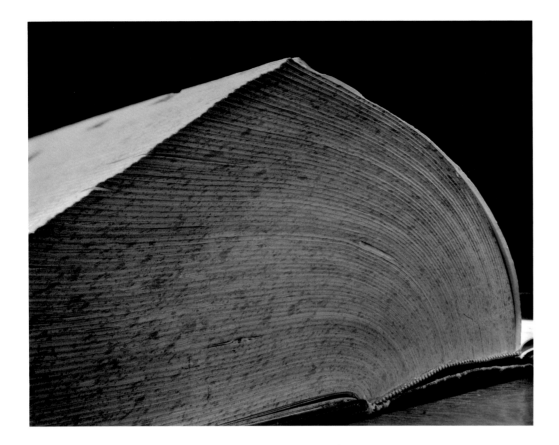

This may turn out to be the most original undertaking of our century: the quest for the magic substance to be found in the ordinary. To attempt that, it has been necessary to peek under our beds and into the darkest corners of our rooms.

"The soul stays home," Emerson told us, and Abelardo Morell concurs. The philosopher Seneca claimed that he could not philosophize in a palace, but only in a pauper's room, where one sleeps and daydreams on a pile of straw. A lived-in room is a trope factory. Its walls and ceiling have been read like a mystery story. The emptier the room, the more intricate the plot. Think of Morell's images of Manhattan caught through camera obscura in empty rooms. Morell's photographs are dream catchers. They objectify our most poetic reveries.

"Every photograph is in a way a test for the viewer's imagination," wrote Mary Price in *A Strange Confined Space* (1994), her invaluable book on photography. This is where the poetry comes in. It is the poet in ourselves who, closing the eyes, enters the imagination's darkroom to recover the speech that bridges the gap between image and word. In that sense, photography is a "medium" in its true sense. It is both a technique and an instrument of the spirit.

Calculation is present in the way Morell explores the optical properties of the camera—varying, for instance, the size of the pinhole—and chance comes into play during the long exposure of about eight hours' time, as he's not able to predict how the weather and light will change and what random images may yet drift in from the street. His aim is to surprise himself and to defamiliarize and undermine our habitual way of experiencing our surroundings by introducing a troublemaking ambiguity between illusion and reality. When chance is invited in, when it cooperates as it does here, it opens a door to what is not ordinarily visible. Chance, the redeemer, needs the camera obscura to show us the poetry of appearances that's always around us.

Underwritten by Emerson and Thoreau more than a hundred years ago, the quest of the ordinary—in American philosopher Stanley Cavell's phrase—is the great project of modern literature and art. The inexhaustible power of common objects continues to be a preoccupation of some of our best photographers and poets.

<p style="text-align:center">✢ ✢ ✢</p>

Morell's titles are usually specific and matter of fact: *Paper Bag, Brady Looking at his Shadow, Two Forks Under Water, Camera Obscura Image of the Sea in Attic, Dictionary,* and so on. We are given the actual, what is in front of the camera, and it's up to us to do the rest. The alternative would be furnishing the photographs with the kind of titles the surrealists used to love to give their paintings and sculptures, titles in which the real is already renamed: *Palace at 4 A.M., Chinese Nightingales, The Snake Charmer, Immaculate Conception, Child's Brain, Enigma of the Day, Captain Cook's Last Voyage,* etc. What we see and what we are told we are seeing are intentionally at odds in such works.

Not so with Morell. His titles tell us: First take a good look at what is in fact there. Admire the formal qualities of this open, brown, paper bag sitting on the floor or this toy horse. The commonplace object is singled out, brought out of its anonymity, and

stands before us fully revealed in its uniqueness and its otherness. In the metaphysical solitude of the object we catch a glimpse of our own. Here is the unknowable ground of appearances, that *something* that is always there without being perceived, the world in its nameless, uninterpreted presence which the camera makes visible. That's what casts the spell on me in Morell's photographs: the evidence that our daily lives are the site of momentary insights and beauties that lie around us to be recovered.

The photographer and the poet share a love for unusual images. Both arts are about intuiting resemblances, noticing how a

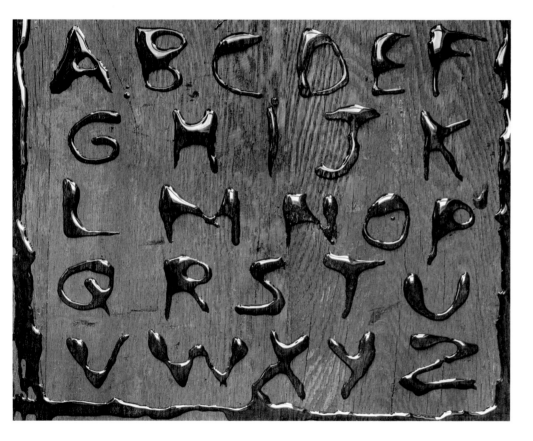

tower of children's blocks can mean more than itself. The ideal is to arrive at an image that would imprint itself on our memory and become inexhaustible to the imagination. Who hasn't made towers of blocks, playing cards, or pennies and grown breathless as the tower begins to sway? The trick is to see it from underneath, to make ourselves as small as some imaginary pedestrian looking up at

its commanding presence. The game being played is the game of becoming smaller or bigger to acquire a new point of view as one yields to the imaginary.

"The individual is not the sum of his common impressions but of his unusual ones," said the French philosopher Gaston Bachelard. Often, of course, the subject matter explains why we remember certain things better than others. A child lying in a pool of blood in the street, or a sheep with two heads at the country fair, is not easily forgotten. But, and this is worth reminding ourselves, we also remember empty rooms, "certain slants of light," tree shadows on the ceiling, odd stains on the bare, wood floor. Memory's museum has room for both the assassinations of Presidents and the image of our grandmother's black comb with a few white hairs in it at the back of a rarely opened drawer.

⁎ ⁎ ⁎

The astonishing aspect of Morell's photographs is their ability to give this old world a new look. What is this he's got here, we continually ask? Morell has found the way to domesticate the fantastic. In this photograph, it seems perfectly natural to find the reflection of sea waves on the ceiling of an attic. How delightful it must be to stretch in a bed with the upside-down image of the Empire State Building and midtown Manhattan hovering over one's head! Morell's is a magic realist show. Nothing is quite what it appears to be. Mirage and reality perform side by side, providing a new aesthetic experience for the viewer.

His photographs of open art books are a part of the same strategy. The camera is held up to the book at a reader's distance, or more accurately, a nearsighted reader's distance. Or even better, this could be the solitary child's view, the child who has just begun to imagine stepping into the picture in the book. Who hasn't done that? This is how children always read their stories, as the philosopher-critic Walter Benjamin reminded us: "Children know such pictures like their own pockets; they have searched through them in the same way and turned them inside out, without forgetting the smallest thread or a piece of cloth. And if in the colored engraving,

Water Alphabet, 1998

17

children's imaginations can fall into reverie, the black-and-white woodcut or the plain prosaic illustration draws them out of themselves" (*Selected Writings*, volume I, 1996).

Who can refuse the temptation to climb Morell's huge dictionary, whose pages invite us to climb them, providing we can make

ourselves very tiny? The smaller I can become in my imagination, the more marvelous the world becomes. This coliseum of Piranesi is now as immense for me as the universe. The whole of creation is a realm of pure imagination, his photographs prove. The world is a big, thick book full of wonders admiring themselves through our eyes.

Morell speaks of his new work done in the Gardner Museum as "marrying faces." "I just love the idea," he says, "that a young

maintenance man (who, as it happens, is also an artist) can portray the same intensity as a young, cocky Rembrandt." We have all had the experience of catching someone viewing a portrait they resemble. In museums in northern Italy, one occasionally meets Madonnas who could have stepped down from the paintings. To discover the same thing in America, with its diverse population, has the feel of Whitman's democratic vistas. "You shall stand by my side and look in the mirror with me," the old poet said, and he meant all of us. As Morell says: "To my mind I think that guards end up looking at these works of art longer than any scholar and that some of the people who work here are as beautiful and haunting as anything on the wall."

In the same letter to me, Morell wrote about wanting to "combine things like a close up of a beautiful silver tea set on display with a secretary's coffee mug next to her computer." This, I think, is the heart of his vision, the perception of similarity in disparate things, the bringing of two separate realities together, not to cancel out their individual properties, but to officiate at an alchemical wedding. A visual innovation is the result of collaging, of discovering the dimension of transcendence out of the literal. For Morell, to find resemblance is to find an image of something never seen before, and to do so as often as he has done it is no small accomplishment for any photographer or poet.

Charles Simic

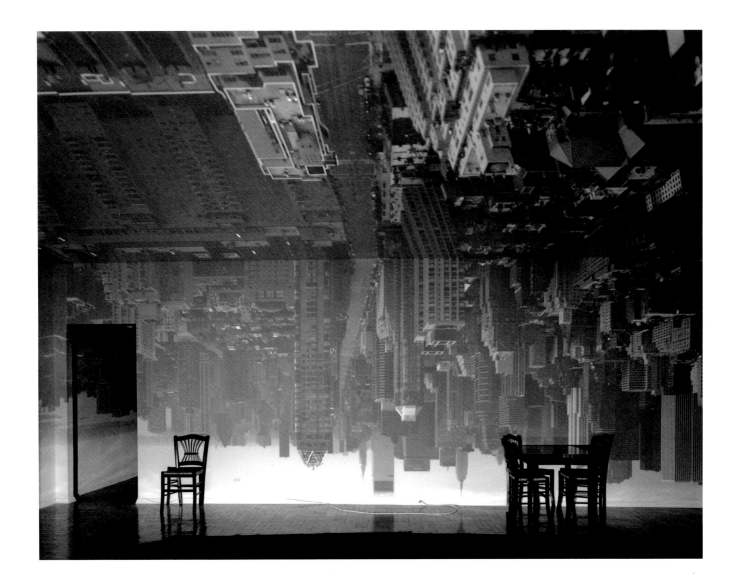

Camera Obscura Image of Manhattan View Looking South in Large Room, 1996

ILLUMINATING SURFACES

I photograph what I do not wish to paint and I
paint what I cannot photograph.
　　　　　—Man Ray

The photograph's subject is unclear at first glance. A wash of light flows across the surface of the image in defiance of the viewer's possessive gaze and casts it aside, out of the picture frame. For an instant the eye flees in dissatisfaction and confusion, turned away from the photograph as a source of meaning and aesthetic gratification. The mind quickly rebounds, sending the gaze back over the picture, this time to indeterminate reward: two fruits balanced on the edge of a table, the negative impressions of a youth's smooth face and muscular arm. These shifting forms are created as light rakes the ink that has been laid over the surface of the book's page.

This artwork is a photograph of a printer's picture, made from a photographer's record of a painter's image. With the sun's assistance, Abelardo Morell has undone the photographic print of a painting by Caravaggio, the Renaissance master of light and shadow. Through a simple process of eliding images on the surface of photographic paper in his darkroom, Morell calls the viewer's attention to the fact that the photograph not only contains signs, but that it is a sign. The photograph's meaning is both subject and product of the viewer's gaze and imagination. On the surface of the photograph, Morell reveals the conflict and uncertainty inherent in knowledge created through the mediation of illumination and darkness in art. Caravaggio's passion was humanistic, even pagan, welling up from his fated life in the company of thieves, harlots, and charlatans. It was in this degraded world that he encountered the transcendent, the holiness to be found in ordinary human experience. In his paintings, Caravaggio rendered an eternal light that cut across the death in knowledge, the ephemerality of mortal flesh, and the deeper darkness of unknowing. The scenes and portraits he painted sent his ideas, his sight, his experience forward through time on the wings of this transforming light, to be caught up in the viewer's eye through the images formed across and through

the surfaces of his paintings. This is what we see when we look at his work.

Caravaggio's revelation of light as a harbinger of knowledge and the creator of images is a truth not lost on Abelardo Morell as he photographed the raised-letter text from a book of Proverbs. The drama of the photograph echoes the formal composition of much of Caravaggio's oeuvre. A searing shaft of light cuts across the surface of the page, mysteriously transforming the text's three-dimensional

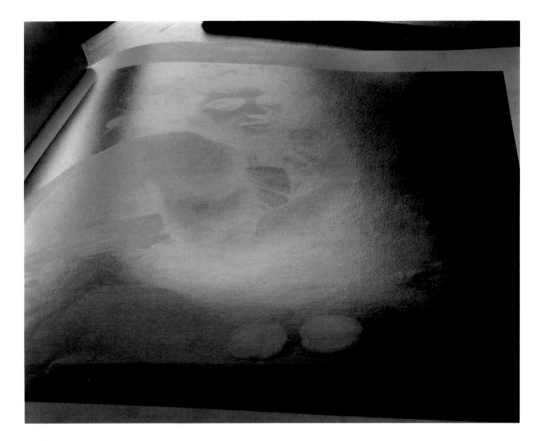

letter forms into tenacious reflectors of light, dispersing them into optical oblivion as images without form, ciphers without meaning. The source of light in Morell's photographs, as in Caravaggio's paintings, consistently comes from outside the picture frame. It is

Book: Boy with Fruit by Caravaggio, 1993　21

light that transcends time, and these artists insinuate that the light in the image comes from the viewer's present experience of the work. It is in this traversing of the boundaries of the frame and the picture plane that meaning and life are created in art each time a viewer brings light onto the surface of the image through the prism of the eye. Morell's fascination with letters is rooted in the function of alphabets as the most apt metaphor for art as both an image and a form of meaning. Language literally constructs images in the mind in the same way the eye constructs vision, building them form by form, developing and framing how objects are seen and given meaning. The photographer is a visual linguist translating the images of the world into form as well as meaning.

Morell was drawn to photography as a medium that has the power to reveal the unseen. His early work was documentary, and as a young graduate of Yale University's M.F.A. program, Morell snapped images of the abundant beauty and hardship that the world yields to the human eye and the camera lens. Believing Robert Frank's tenet that "the truth is somewhere between the documentary and the fictional," Morell looked for and found the surreal in the ordinary, cataloging his awareness of our image-choked world, spilling over with unrecorded truths.

With the start of his family, Morell's camera was turned toward the most familiar world of his house, family, and neighborhood. Not only did his camera function as Roland Barthes has described this tool, "as a clock for seeing," but it enabled Morell to possess the images of his world in the way of a child—awed, curious, yet unfazed by the objects and the images that are the common fruit of a nurturing yet sheltered domestic experience. The work from this time transformed Morell's relationship to the world in which he had previously been a mere observer. The voyeur became the unseen protagonist of each of these photographs, whose presence enters each room, construction, and portrait as a muse, intent on creating as well as on experiencing the wonder of the camera's ability at observation.

In *Brady Looking at His Shadow*, Morell photographed his young son in a posed portrait. The boy's shadow is the focal point of the image, as it records a heroic posture, the boy's arms arched away from his torso as if to present a young superhero. Additional shadows ripple and fade behind this primary form. These echoes of an

image belie the innocence implied in the photographing of a child. They reveal the photograph as the posed image of a child as everyman, constructed by a knowing adult. As the viewer looks more closely, he or she observes the boy's fatigued, nonheroic posture. Tired of the photographic session that may have begun as a spontaneous game, Brady grabs the sides of his trousers for support in holding the pose. His shadow is an image formed by light, as is the

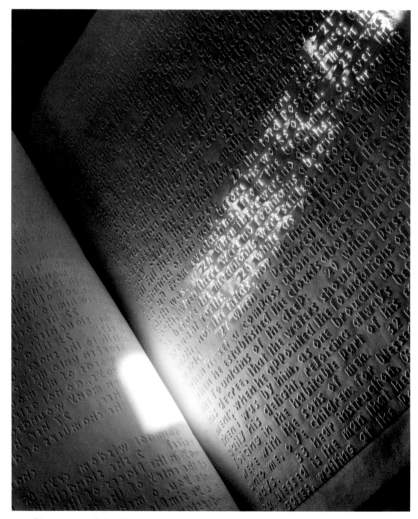

profile view of the boy recorded in the photograph. The presentation of both images side by side simultaneously confirms the camera's inability to decipher meaning and its usefulness at recording likeness. Like a shadow, the photograph is a true image, but it is only

one image out of many that live between seeing and comprehension. Through his determination of the view recorded in each of his photographs, Morell shares with the viewer what is important to see and confirms that its significance was hidden until the camera brought it into focus. It is up to the viewer to decipher how the truth in the image will teach him or her its meaning.

Morell's questioning of the meaning in images led him to the conflation of textual and pictorial content that occurs in illustrated

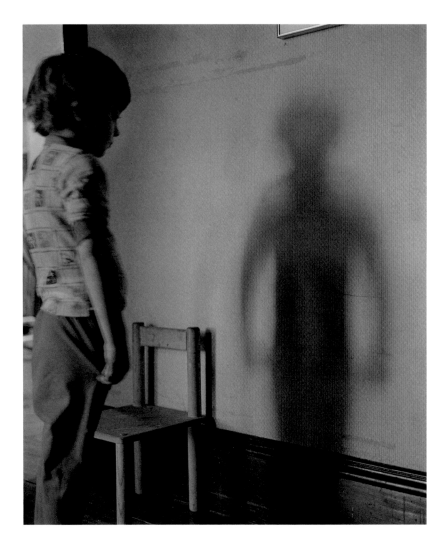

books. His interest in this convergence of image and form flourished during an artist's residency he held at the Boston Athenaeum in 1995. His photographic practice shifted from recording the

images to be revealed in people and places to photographing the images found in the Athenaeum's extraordinary collection of illustrated books. Morell became fascinated with the oddity and artificiality in the construction of book illustrations. As reproductions, book illustrations provided Morell with a ready-made resource for exploring the physicality of ink on paper, the photographer's palette, and the meaning to be revealed in these images used as objects and reinterpreted as images.

Morell's embrace of book illustrations as the subject of his photographs also allowed him the opportunity to exorcise the common misperception of photography as mere surface imagery. Recreating the visual tactility of two-dimensional surfaces through these works, Morell reminds the viewer of the nuanced comprehension of physicality that comes through the eye, without which our fingers would be confounded by such subtleties as the difference between wet and dry color or between soft and impervious form. *Book: Portraits by Da Vinci and School of Da Vinci, 1993*, exemplifies Morell's fascination with the camera's ability to transcend the boundaries of physics and time as it records two illustrations overlaid on each other in the turning of a page. In this photograph, which weds two portraits of Cecilia Gallerani, *Lady with an Ermine* and the so-called *Belle Ferronnière*, Morell reflects upon the standards of authenticity and connoisseurship by which the history of images have been edited. The photographer's fingers pool mysteriously in the surface of these images as if they were a pan of darkroom chemicals out of which another meaning is yet to emerge. Morell's nod to the transformative moment in the darkroom before the image appears on the photographic paper surface recognizes the element of chance inherent in the creative process and the making of meaning. It is in the darkroom that the photographer confronts the camera in his hand as independent from the image maker or interpreter in his mind. This camera has its own lens, one that consistently engages the photographer in a process of seeing that is outside of his head and closer to his physical experience of the world.

Morell's hand soaks simultaneously in the photograph's records of art and creativity. His fingertips touch the arm of the concurrently young and old sitter, who may have been well-known in her life but whose portraits have made her famous through time. Her confident gaze recognizes the makers of her portraits, both Da Vinci

Brady Looking at His Shadow, 1990

and Morell, and reveals her self-consciousness. Through reproduction, she is also able to gaze out of a book and into whatever room and toward any viewer into whose hands the book has fallen. Cecilia Gallerani's mysterious gaze is transformed from quixotic history into clever commentary on an image's desire to transcend physical and temporal boundaries to achieve significance outside the book in the viewer's frame of reference, as in Morell's photograph of a book containing a reproduction of the Italian painter Raphael's portrait of Count Tommaso Inghirami, chief librarian to the Vatican under Pope Julius II.

This exhibition of photographs at the Isabella Stewart Gardner Museum is a record of Abelardo Morell's scrutiny of a collection of art that is a physical place built of multiple images (paintings, sculpture, landscape, tapestries, and tableaux of objects) as much as it was built of stone and mortar. His photographs help the viewer take imaginary possession of a space in which they are cultural tourists traversing an unfamiliar and exotic terrain. Morell mediates the impressive and somewhat daunting sensual overload of images at the Museum, enriched through texture, scent, and aural reality, by bringing the experience down to image size. His choices of subject matter tell us where his professional eye has made editorial contact with the tactile experience of the collection. Morell's camera negotiates the torpor of the Museum as an unchanging context. Its lens refracts and transforms the images of the collection into fresh, visual experience enabled to pass through time and space, from the Dutch gallery into the contemporary exhibition space, from Isabella Gardner's unchanging contextualization of objects in the Museum into the world. It is through the mediation of the camera that Morell is able to measure out a portion of the Museum that is comprehensible so that he can savor his own experience of this place. The subjects that inhabit his photographs reveal that his standard for viewing this historical collection is not formed by traditional museum cataloging methods but is determined by the eye of an experienced photographer looking for meaning across the surface of objects in time.

Abelardo Morell's encounter with the meanings to be discovered in the images at the Gardner Museum occurred in direct response to the life he observed in the Museum through its staff. He was compelled by the notion that these individuals experienced this extraordinary collection of art on a daily basis while fulfilling rou-

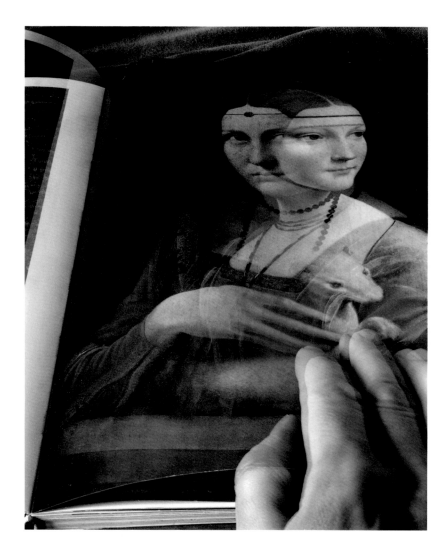

tine responsibilities and that these quiet encounters imbued the art with its most consistent life, meaning, and relevance. *Tim and Rembrandt, Gardner Museum, 1998*, clearly conveys Morell's faith in the twentieth-century significance of Rembrandt van Rijn's *Self-Portrait*. The correlation between the two portraits, one of a man, the other of an image of a man, is striking. The sitters are literally grounded within the context of their shared space of the Gardner Museum, as Morell separately exposes two halves of one negative to form one black-and-white image. Thomas (Tim) Allen's pose echoes that of Rembrandt in his *Self-Portrait*, as each sitter has donned a hat, a signal of style and self-confidence. By stylizing the images, Morell creates an equivalence in the photograph's content and its physical

Book: Portrait by Da Vinci and School of Da Vinci, 1993

presence. Two confident young artists appear side by side, their eyes revealed as the windows to their souls. These eyes are receptors of light in the past tense and reflectors of light in the present. We recognize in them that our perception of these individuals, who function as signifiers of the early seventeenth century and the late twentieth century, has been paralleled on the surface of the photographic image to reveal new meaning.

This pairing of a contemporary individual and art transforms both images. Tim Allen's image as an artist is reinforced, while the painting of Rembrandt, enlivened by Allen's presence, is reduced in its identity as art and reinforced in its depiction of a man. Despite the solidity of Allen's form, Morell's photograph undermines the perception of photography as a truer creator of likeness through a print that clearly affirms the rich impasto created by Rembrandt's deliberate brushstrokes. Morell's effort reinforces the union of the two images as art. The composite format, however, reminds us that the once-unprecedented image of Rembrandt is no longer unique, due to the reproduction capabilities of photography. Rembrandt, like Caravaggio, has successfully traveled through time to a place where the meaning and life of his image have well-exceeded any expectation, perception, or meaning the artist may have conceived. In turn, perhaps the contemporary artists Tim Allen and Abelardo Morell view the future life of their own work in the same extensive temporal context as Rembrandt's. Reflection on the notion of their work as the pictorial record of their present as well as the viewer's, as the history of the future, is a sobering consideration. Their unspoken presence in the viewer's experience of the Rembrandt confirms an exponential expansion of the image's meaning to a moment where Rembrandt's *Self-Portrait* has become a portrait of portraiture and an image of a living artist. On the surface of *Tim and Rembrandt, Gardner Museum, 1998*, the present has become the continuous, indefinable, unseverable link between past and future.

Morell's representation of historical images is an investment in the history and life of art through a recreation of images that emphasizes their present life through the viewer. Images are the past tense of reality. When they give way to time in the present tense of immediate spatial experience, instead of standing as nostalgic evidence in defiance of it, there is art. Abelardo Morell is interested in images as an artist who seeks to affirm the truth in acts of perception rather than intellectual comprehension. For him art, specifically photography, is the looking glass that affords modern man passage back to the truth in experience. His work affirms that art is simultaneously obsolete and necessary, that it provides an understanding that has no other access point. Without art mankind would not be able to find its way back to a more essential identity, either as individuals or as a developing historical culture.

The fascination inherent in this pairing of history and the present holds true in Morell's *Joan and Sir William Butts, M.D., Gardner Museum, 1998*. The apparent likeness in these images is uncanny. Joan Hallaren, dressed in the professional attire of a guard at the Gardner Museum—like Dr. Butts, who is attired in a manner appropriate to

Book: Portrait of Inghirami by Raphael, 1993 25

his station as a well-regarded physician in the sixteenth century—is somber but clearly conveys the responsibilities of her office. Morell has carefully posed his subject and reproduced the directness of her gaze. Her image is close to the surface of the photograph, leaving no space in which the viewer can mediate the intensity of her stare. In this encounter is no room for the casual regard of the distant consumer of aesthetic images. Unlike the profile of Dr. Butts, Joan appears to dare the viewer to see her without her permission. This photograph begs the question of image as a privately possessed and guarded object, as precious as a masterpiece. Commenting on this issue when he was asked to consider the reproduction of a photograph of himself on the cover of a pamphlet, Roland Barthes wrote in *Camera Lucida* (1981), "The 'private life' is nothing but that zone of space, of time, where I am not an image, an object. It is my *political* right to be a subject which I must protect." Morell's photograph reveals the unprotected identity of images throughout time, their meaning subject to the projection and consumption of willful, wishful viewers. In *Joan and Sir William Butts, M.D.*, Morell has empowered Joan Hallaren to retain the value of her identity in present time and for the future. The viewer is clearly relegated to a knowledge of likeness, not individuality.

Morell's portraits not only are representations of a subject but also can serve as poignant homages. *Two Gardens, Gardner Museum, 1998,* is the photographer's poetic tribute to the nobility inherent in work. Pairing a garden tapestry from the Gardner Museum's Little Salon with a gardener watering in the Museum's courtyard, Morell's image brings together the beauty wrought out of painstaking labor in the creation of the tapestry and the gardener's meticulous care in the nurturing of the Museum's horticulture. The extraordinary three-dimensional construction of plants in the weave of the tapestry image is well met in the rich foliage presented in the courtyard. The architectural and horticultural symmetries captured in this composite image reinforce the cohesion of the images' extreme spatial and temporal disparities. Through this photograph, Morell and the viewer share an understanding of the deep-rooted continuum in human experience, despite revolutions in cultural, political, intellectual, and religious value systems through history.

This first photographic project of the artist's residency in which he brought art and observer face to face in one image led Morell to additional pairings of images in the collection through which he addressed the life of artwork in the Gardner collection. It was Morell's appreciation of the mobility of books and their ability to bring images into private physical and mental spaces that motivated him to create new and unstructured views of permanently sited paintings. *Two Paintings Sharing an Archway, Gardner Museum, 1998,* is a photograph of two works that hang opposite each other in the Raphael Room of the Museum—Sandro Botticelli's *Tragedy of Lucretia* (on the east wall) and *The Annunciation*, attributed to Piermatteo d'Amelia (on the west wall). Under the archway depicted in each of these paintings lies the point of infinite perspective, the aesthetic chalice of spiritual perfection in painting in sixteenth-century Italy. While seemingly frozen in time and place, these depictions of spiritual excellence and purity (Lucretia and Mary, the chaste and devout brides of both man and God) are not free from time's unflagging demands on form and meaning, as the paintings are made of ephemeral matter destined to crumble and fade. Unlike the stoic, unmovable virtue represented in each of these artworks (affirmed in their installation across from each other to create a central position in which the viewer stands in the locus of perfection, enabled to "see" infinitely), Morell's photograph reminds us that their material reality, like that of the viewer, is limited and entropic. The photograph's prioritization of perception over intellectual understanding restores true value to these works, supplanting their appreciation as tokens of creative genius or imperishable wealth. The seam in the photograph represents the place in the viewer's mind where the two images are conjoined in the gallery, an optic impossibility and a fleeting imaginative feat. The experience is ephemeral and subjective, but authentic and profound, unweakened by the acknowledgment of its value as a truth achieved through inspiration. Morell reinstates the religious mystery and political fervor that these artworks possessed in the time of their creation by recreating in the modern viewer the faith through which they were originally seen. He does this in his seamless joining of disparate realities beyond reason on the field of his own imagination on the surface of the photograph.

Morell explores similar issues concerning the life and death of images and meaning in art in a more disconcerting form in *Exquisite Corpse, Gardner Museum, 1998.* Experimenting with his observation that

relationships in art are not necessarily ones of outward form but can be founded on inner sympathies of meaning, Morell dismembered and then reconstructed objects and images in the collection. He did this in order to create a body that would transcend the archetypal depictions of the human male form that have developed over many centuries and in various mediums. A sixteenth-century procurator's portrait, a classical carved marble torso, and the painted

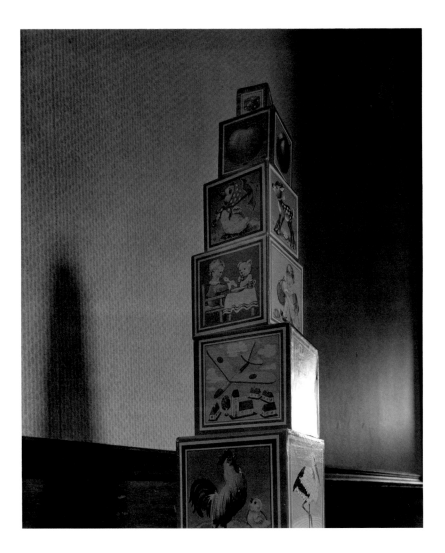

legs of an Eveless Adam are collaged together in emulation of the surrealist parlor game Cadavre Exquis. In this game, a different artist would each draw the head, torso, and legs of a figure on a single piece of paper without seeing to what they would be joined, each

section of the page folded to hide the efforts of each successive artist. The fantastic images that resulted from these sessions became exposés of the wild, imaginative culture of the artists' subconscious minds. Morell's masculine ideal is an aesthetic monstrosity, a pastiche of dislocated images that dramatizes the secondhand nature of the experience offered a viewer by pictures of objects.

In direct contrast to the complex meanings that resonate in *Exquisite Corpse*, Morell's *Detail, Gardner Museum*, 1998, reveals the camera's ability to turn any subject into a work of art. Photography has the same perspective and framing as painting, a paternity that reinforces the medium's self-definition as the offspring of a long line of methods of pictorial representation. Continuing his early interest in directly recording objects (as in *Toy Blocks*, 1987), in *Detail* Morell conveys his celebration of the ordinary when it is carefully observed, as an ideal of beauty and expressive form.

As the writer and philosopher Susan Sontag has stated, photography is in essence a practice of voyeurism, and "like sexual voyeurism, (taking photographs) is a way of at least tacitly, often explicitly, encouraging whatever is going on to keep on happening" (*On Photography*, 1973). This is Abelardo Morell's primary motive in his photographic record of his experience of the regular exchange of meanings that occurs between images at the Gardner Museum. Morell's photography affirms and facilitates Isabella Stewart Gardner's well-conceived, original aims in the creation of her Museum. Morell honors her idea and ideals in his photograph *Isabella in the Little Salon, Gardner Museum*, 1998, through which he reintroduces Isabella Stewart Gardner into her own collection as it exists at the end of the twentieth century. Morell transposes Anders Zorn's portrait of Isabella Stewart Gardner into the Little Salon, light streaming into the room on each side of her, enlivening her spectral appearance. In this photograph, Morell defers to Isabella Gardner's creative powers, honoring not only her ability to create powerful aesthetic images through the installation of her collection but also her artfulness in directing and orchestrating the resonance of her own image through time. This exemplifies the unique appointment of photography to join the ephemeral passions of humanity with the objects of their passions, the essences of photography and life that art critic and writer John Berger identified as "and our faces, my heart, brief as photos."

Toy Blocks, 1987

Perhaps this is why during most of her life Isabella Stewart Gardner chose to shield her face from the limiting definition of turn-of-the-century portrait photography. Not only was portrait painting more forgiving, but Gardner had already utilized the ability of painting to function as creative fiction in her own collection and was confident of its allure. Would we have preferred an Abelardo Morell photograph of Isabella Stewart Gardner to John Singer Sargent's portraits? Aesthetic appreciation might not permit one's fancy to stray so far from reality as to consider such a proposal, but perhaps the paintings of Isabella Gardner do not give the viewer enough of her. It is not an image that is desired of the photograph but a nail from a True Cross, a vestige of the founding sensibility and editorial eye that created the original play of meanings on which Isabella Gardner founded her Museum. As Susan Sontag, in *On Photography*, has aptly identified,

> . . . a photograph is not only an image (as a painting is an image), an interpretation of the real; it is also a trace, something directly stenciled off the real, like a footprint or a death mask. While a painting, even one that meets photographic standards of resemblance, is never more than the stating of an interpretation, a photograph is never less than the registering of an emanation (light waves reflected by objects)—a material vestige of its subject in a way that no painting can be. Between two fantasy alternatives, that Holbein the Younger had lived long enough to have painted Shakespeare or that a prototype of the camera had been invented early enough to have photographed him, most Bardolators would choose the photograph. This is not just because it would presumably show what Shakespeare really looked like, for even if the hypothetical photograph were faded, barely legible, a brownish shadow, we would probably still prefer it to another glorious Holbein. Having a photograph of Shakespeare would be like having a nail from the True Cross.

Isabella Stewart Gardner understood the limits of photography at the turn of the century. Few photographs of her exist in which her face was not artfully shielded by the netting of a hat or the distortions of distance. Paintings made more room for meaning, not by the nature of the medium but by the nature of the viewer's expectations of the image. Photography used to be limited by the power of its supposed veracity. A photograph was a document. Today photography is granted to offer the same threshold for meaning that painting offered its viewers at the turn of the century. Both are perceived as creative abstractions, which offer themselves as both subject and object of the viewer's gaze, as latent experience. For all postmodern artists like Abelardo Morell, the meaning of images is always contingent on their context, but that context need not be limited by space and time. Photography enables Abelardo Morell to create pictures that traverse space and collapse centuries. These photographs will go out from the Isabella Stewart Gardner Museum. They will take with them Cecilia Gallerani, Tim Allen, Dr. Butts, and Isabella herself, images formed of light and ink which dance in between the darkness in knowledge and the illumination of perception. Meanings pool across the surface of these photographs, and their art will alight in the eye of anyone who dares to take a second look.

Jennifer R. Gross

PLATES

Tim and Rembrandt, Gardner Museum, 1998

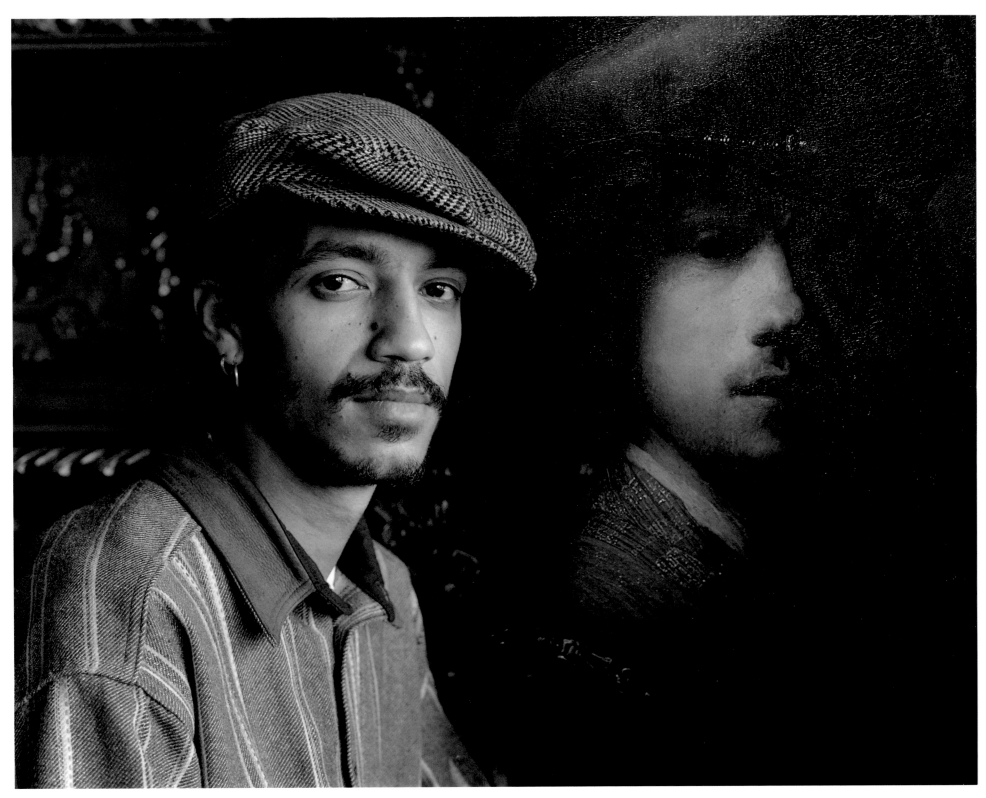

Joan and Sir William Butts, M.D., Gardner Museum, 1998

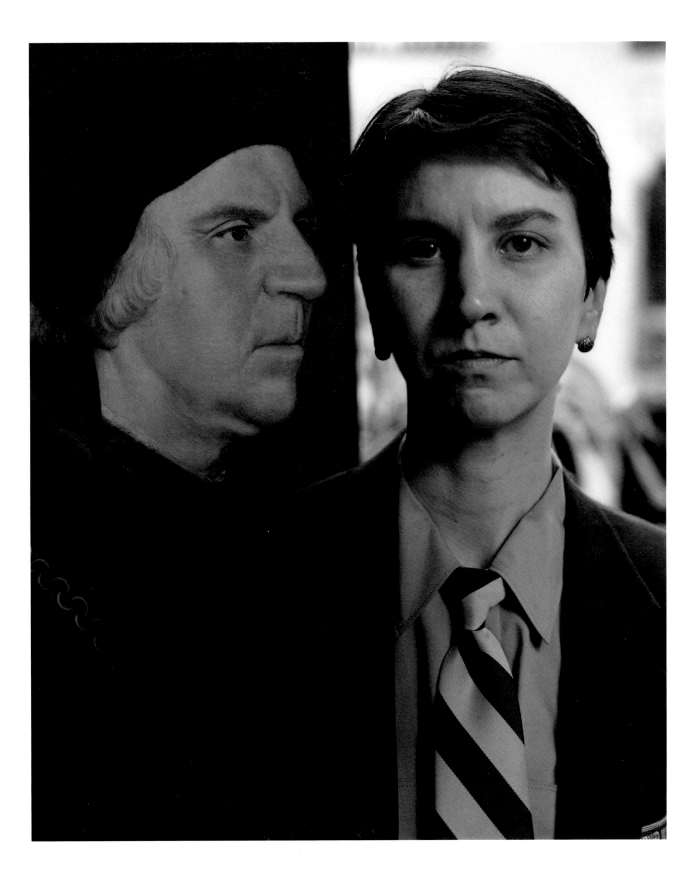

David and the Earl of Arundel, Gardner Museum, 1998

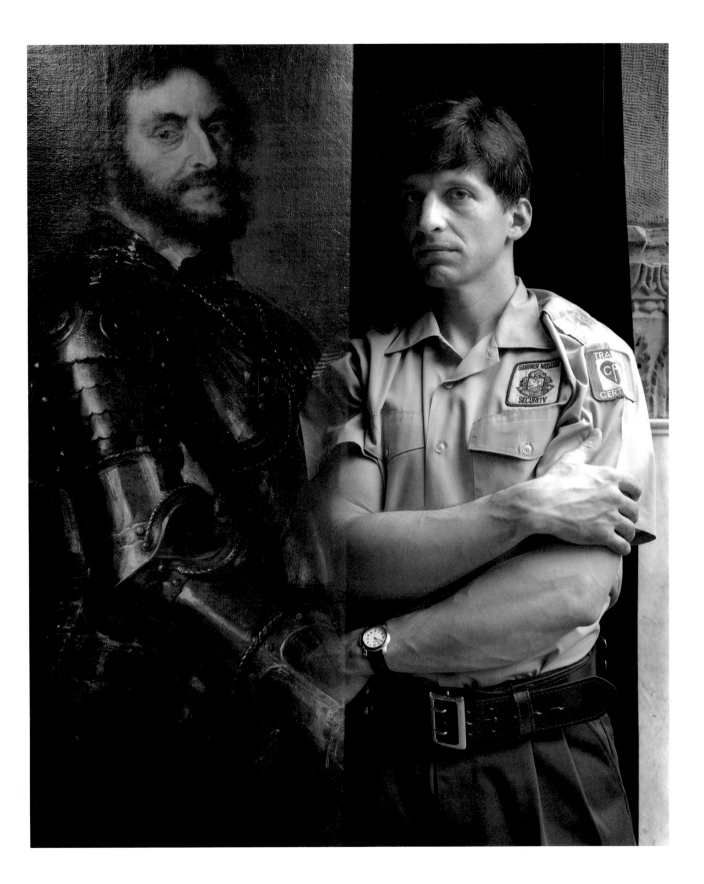

Two Gardens, Gardner Museum, 1998

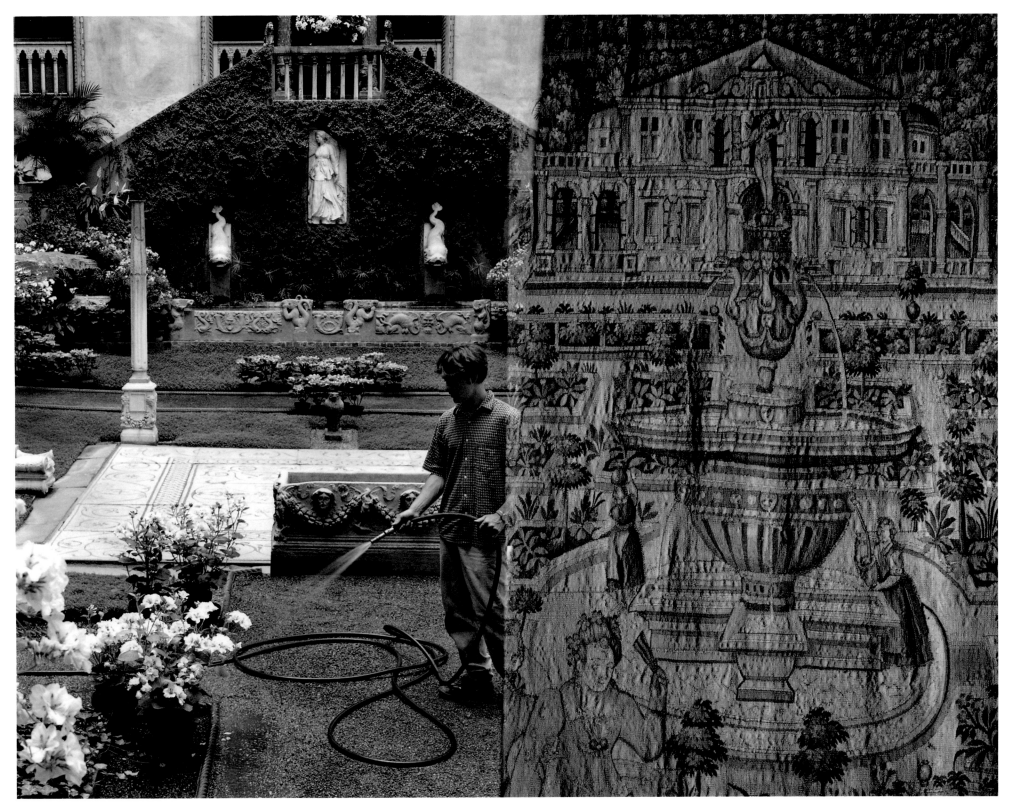

Detail, Gardner Museum, 1998

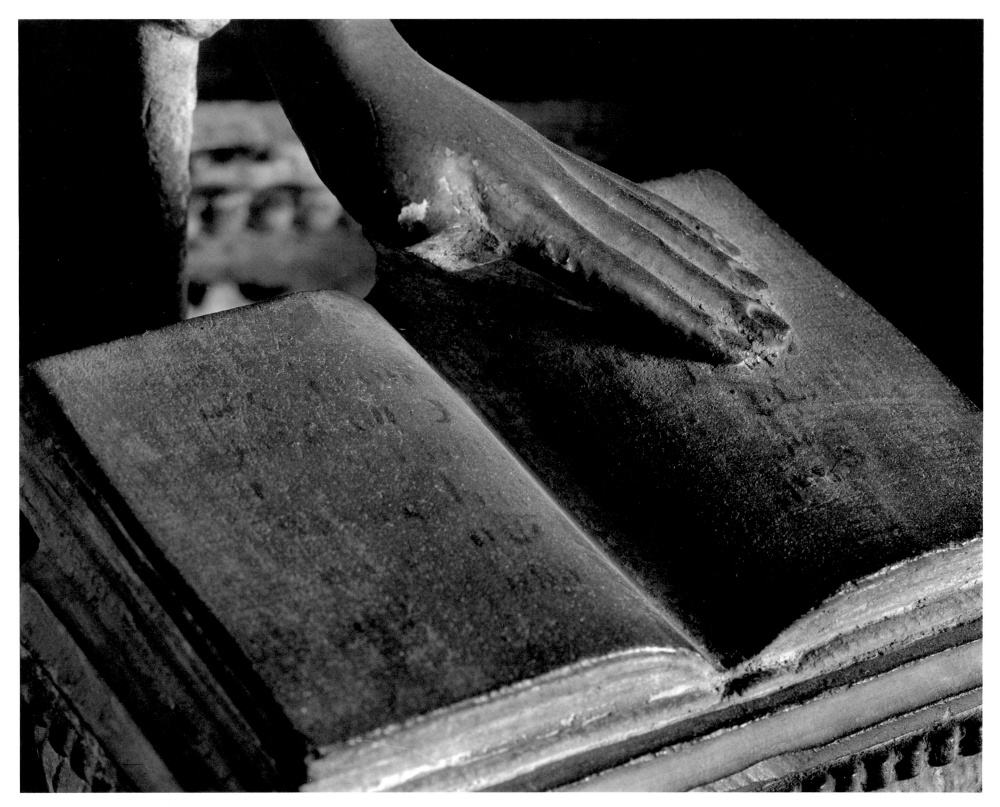

Two Paintings Sharing an Archway, Gardner Museum, 1998

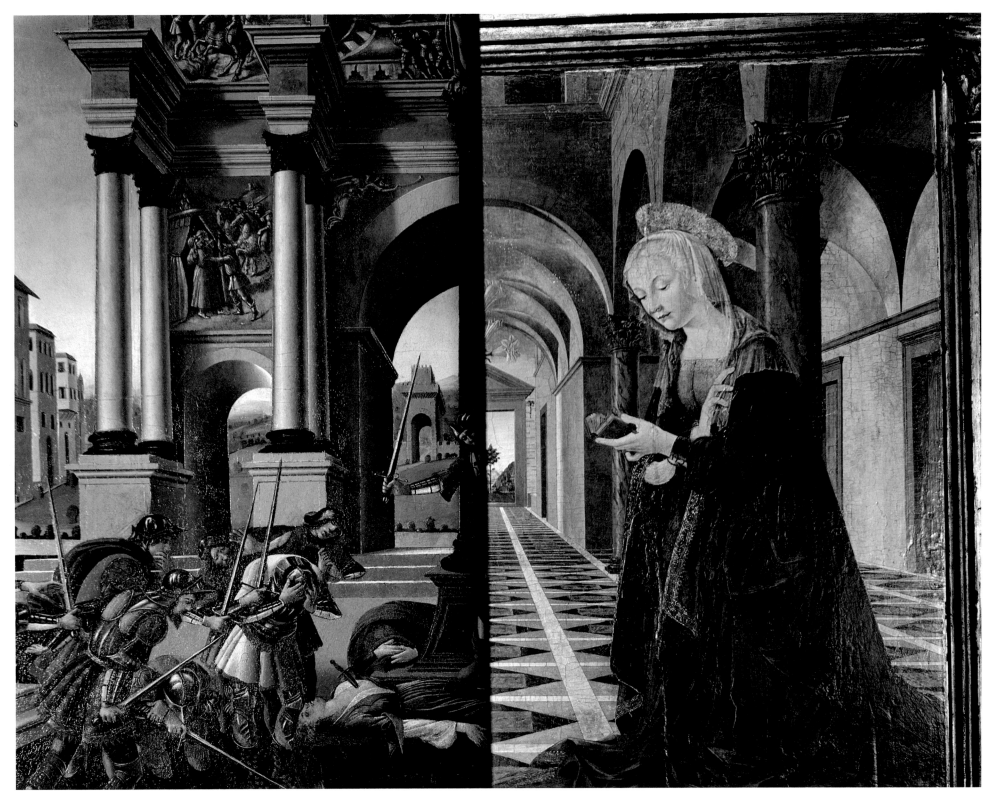

Portal, Gardner Museum, 1998

Man and Woman, Gardner Museum, 1998

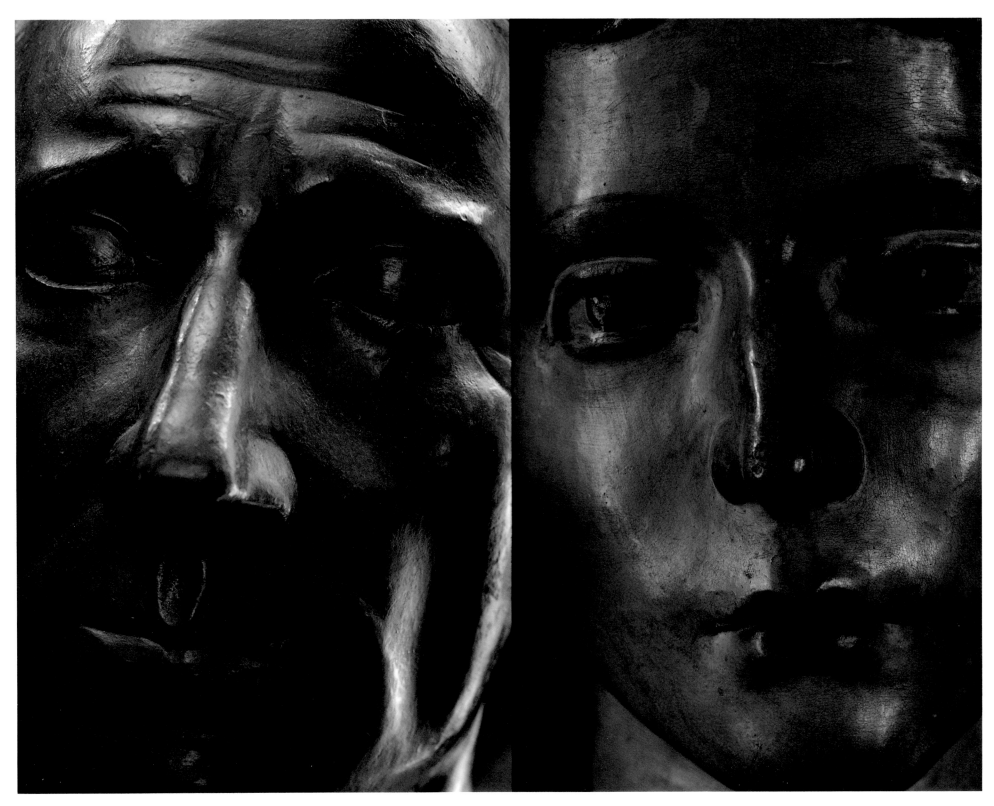

Mother and Son, Gardner Museum, 1998

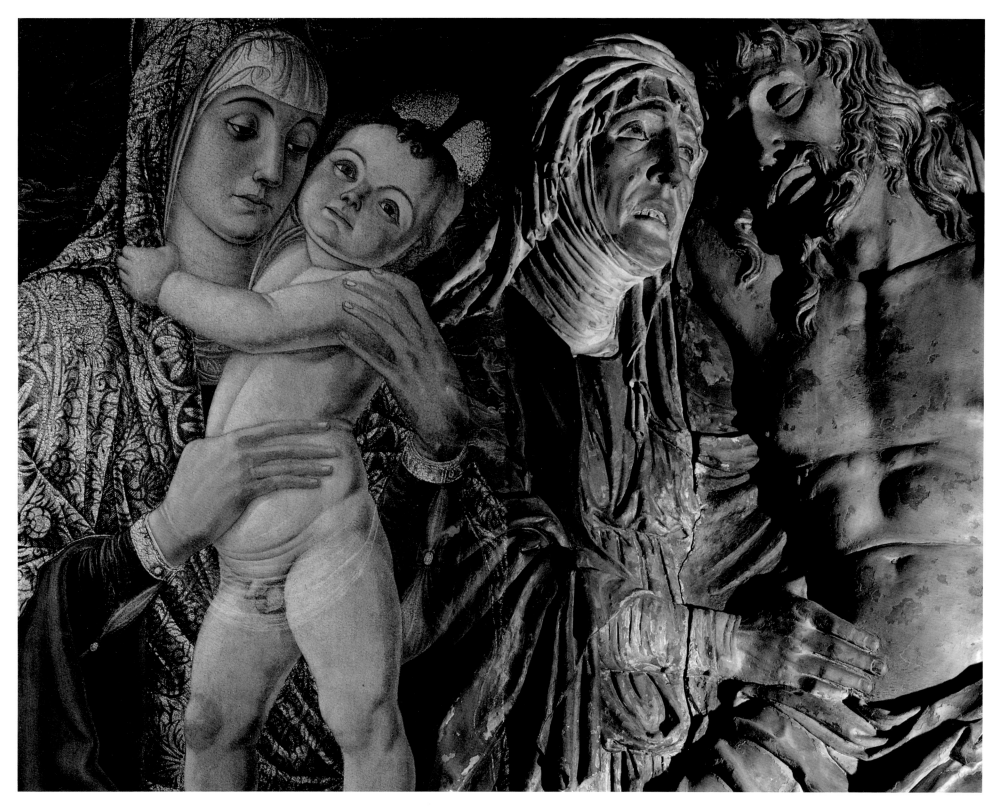

Europa Dimly Lit, Gardner Museum, 1998

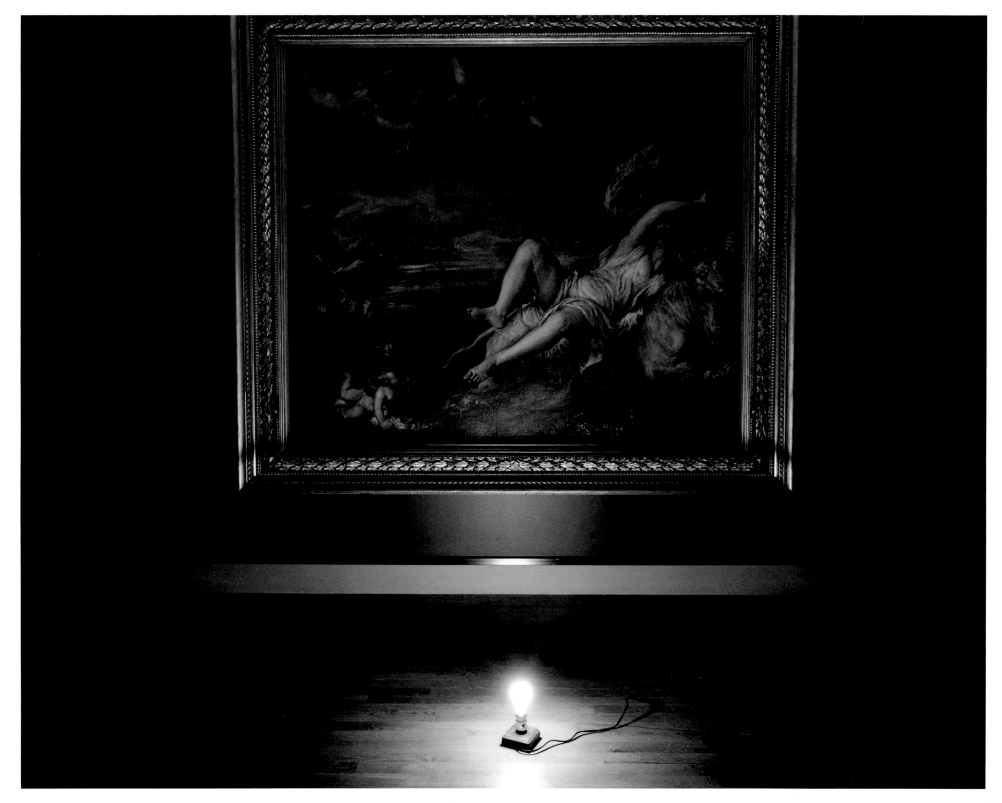

Exquisite Corpse, Gardner Museum, 1998

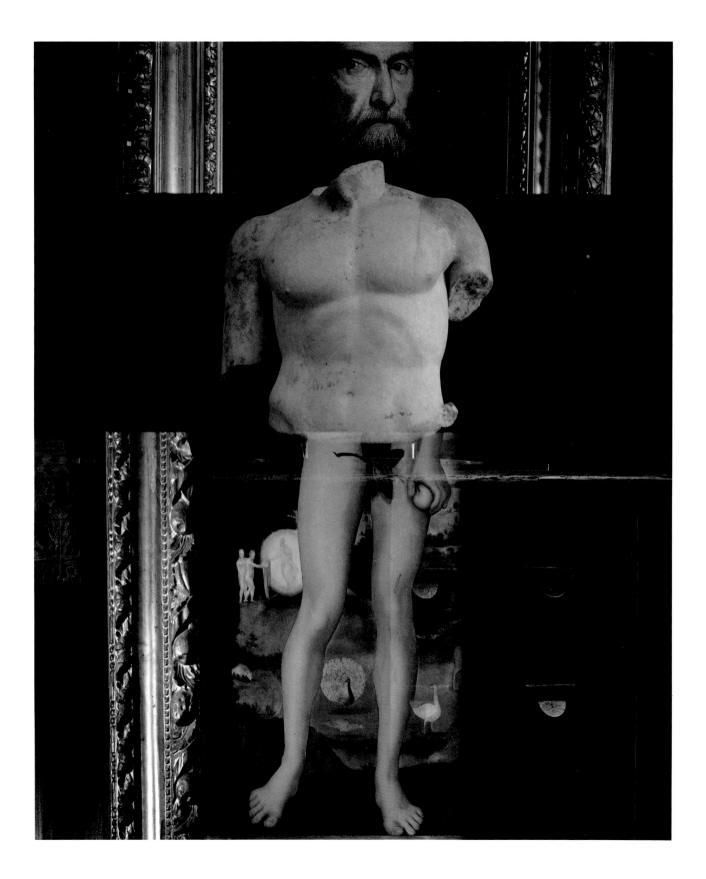

Bust near Painting, Gardner Museum, 1998

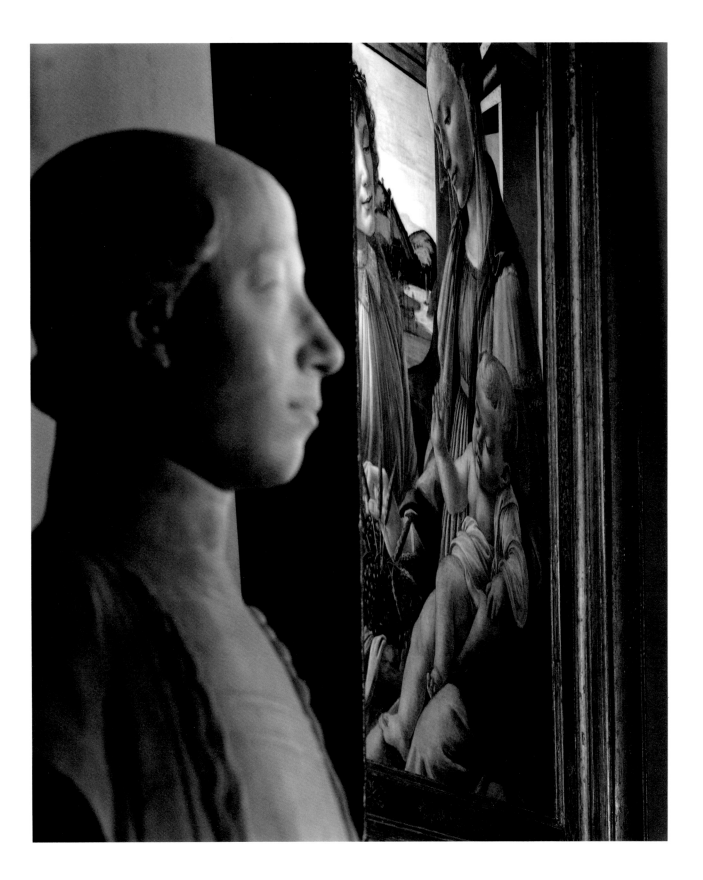

Relief, Gardner Museum, 1998

Women from Three Paintings, Gardner Museum, 1998

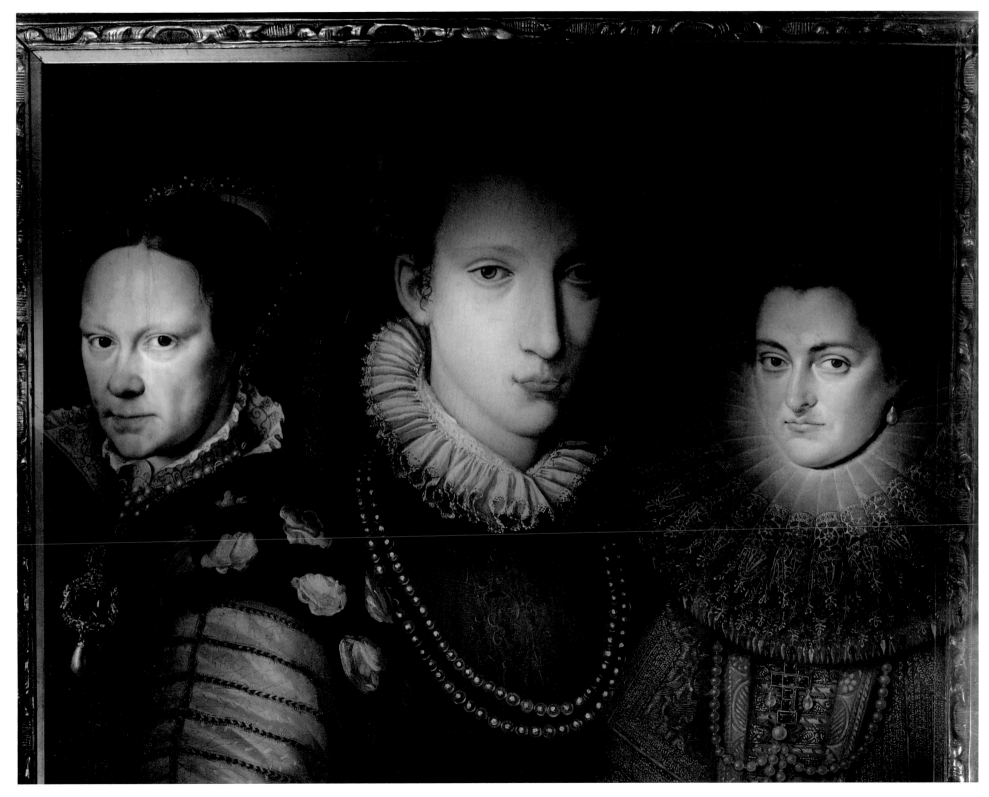

Isabella in the Little Salon, Gardner Museum, 1998

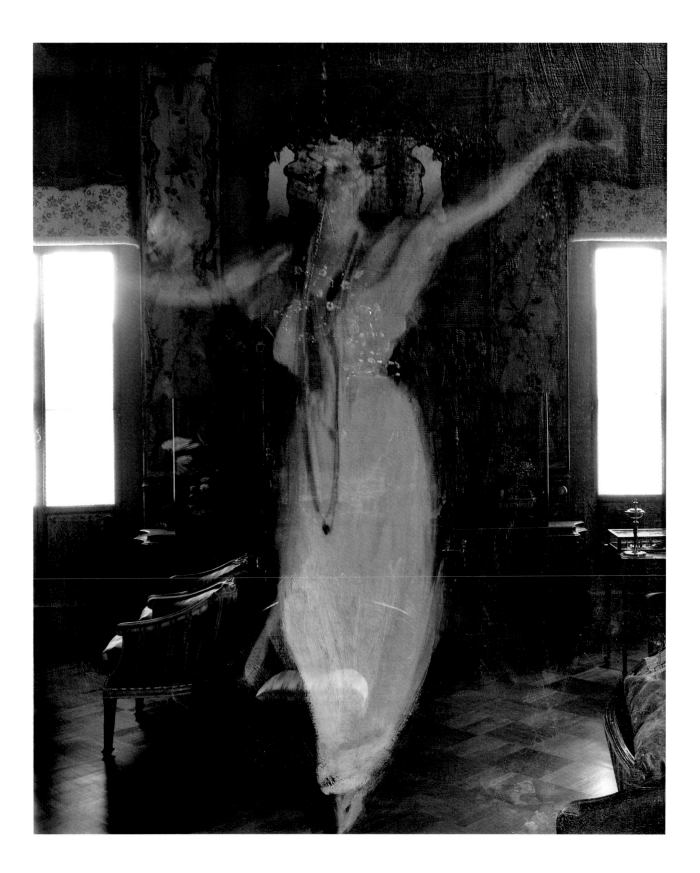

ABELARDO MORELL: BIOGRAPHICAL INFORMATION

BORN
1948, Havana, Cuba

EDUCATION
Bowdoin College, Brunswick, Maine. Doctor of Fine Arts,
 Honorary, 1997
Yale University School of Art, New Haven, Connecticut. M.F.A., 1981
Bowdoin College, Brunswick, Maine. B.A., 1977

AWARDS
1995 New England Foundation for the Arts Fellowship
1995 St. Botolph's Club Foundation Award
1993 John Simon Guggenheim Memorial Fellowship
1992 Cintas Foundation Fellowship

SELECTED ONE-PERSON EXHIBITIONS
1998
Abelardo Morell and the Camera Eye retrospective exhibition originating
 at the Museum of Photographic Arts, San Diego, California; and
 traveling to the Museum of Fine Arts, Boston, Massachusetts;
 Bowdoin College Museum, Brunswick, Maine; and the Saint Louis
 Art Museum, Saint Louis, Missouri
Bonni Benrubi Gallery, New York, New York
Pictured Pages, The Cleveland Museum of Art, Cleveland, Ohio

1996
Fraenkel Gallery, San Francisco, California

1995
Boston Athenaeum, Boston, Massachusetts
Robert Klein Gallery, Boston, Massachusetts
Jan Abrams Gallery, Los Angeles, California
Jackson Fine Art, Atlanta, Georgia

SELECTED GROUP EXHIBITIONS
1998
DeCordova Annual Exhibition
DeCordova Museum, Lincoln, Massachusetts

Then and Now and Later: Art Since 1945 at Yale
Yale University Art Gallery, New Haven, Connecticut

Cuba On
Generous Miracles Gallery, New York, New York

Paraphotography
Maier Museum of Art, Randolph-Macon Women's College,
 Lynchburg, Virginia

1997
*Breaking Barriers: Selections from the Museum of Art's Contemporary
 Cuban Collection*
Fort Lauderdale Museum of Art, Fort Lauderdale, Florida

Process on Paper: Recent Acquisitions
The Brooklyn Museum of Art, Brooklyn, New York

Several Exceptionally Good Recently Acquired Pictures XI
Fraenkel Gallery, San Francisco, California

Tokyo Biennial
The Tokyo Metropolitan Museum of Photography, Tokyo, Japan

American Voices (traveling exhibition)
Smithsonian Institution International Gallery, Washington, D.C.

Some Things
Southeast Museum of Photography, Daytona Beach, Florida

Master Works of Photography from the San Francisco Museum of Modern Art
Ho-Am Art Museum, Seoul, Korea

Measuring Time: Selections from the Permanent Collection
Museum of Photographic Arts, San Diego, California

Oceans & Galaxies
Karen McCready Contemporary Art, New York, New York

The Heart Doesn't Break, It Stretches
Sarah Morthland Gallery, New York, New York

Making It Real (traveling exhibition)
The Aldrich Museum of Contemporary Art, Ridgefield, Connecticut

1996
Fine Artists Books
Baumgartner Gallery, Washington, D.C.

Legacy of Light: Master Photographs from the Cleveland Museum of Art
The Cleveland Museum of Art, Cleveland, Ohio

Anxious Libraries
Photographic Resource Center, Boston, Massachusetts

Through the Lens: Selections from the Permanent Collection
George Eastman House, Rochester, New York

Spaces for the Self: The Symbolic Imagery of Place
The Museum of Contemporary Photography, Chicago, Illinois

1995
Inaugural Exhibition
Megan Fox Gallery, Santa Fe, New Mexico

Degrees of Abstraction: From Morris Louis to Mapplethorpe
Museum of Fine Arts, Boston, Massachusetts

The Photographic Condition
San Francisco Museum of Modern Art, San Francisco, California

An American Century of Photography: From Dry Plate to Digital
Hallmark Photography Collection (traveling exhibition),
 International Center of Photography, New York, New York

1994
New Photography 10
The Museum of Modern Art, New York, New York

American Voices
FotoFest, Houston, Texas

The Reckless Moment
The Art Institute of Chicago, Chicago, Illinois

Selections from the Permanent Collection
The Metropolitan Museum of Art, New York, New York

1993
In Camera
Museum of Fine Arts, Museum of New Mexico, Santa Fe,
 New Mexico

Photography: Close-up/Still Life
Museum of Fine Arts, Boston, Massachusetts

1992
More Than One Photography: Works Since 1980 from the Collection
The Museum of Modern Art, New York, New York

1991
Pleasures and Terrors of Domestic Comfort
The Museum of Modern Art, New York, New York

SELECTED PUBLICATIONS
A Camera in a Room: Photographs by Abelardo Morell
Smithsonian Institution Press, Photographers at Work Series,
 Washington, D.C. (1995)

Alice's Adventures in Wonderland, by Lewis Carroll
Illustrated with photographs by Abelardo Morell,
 with an introduction by Leonard S. Marcus
 Dutton Children's Books, New York, New York
 (October 1998)

SELECTED PUBLIC COLLECTIONS
Amon Carter Museum, Fort Worth, Texas
The Art Institute of Chicago, Chicago, Illinois
Baltimore Museum of Art, Baltimore, Maryland
Bowdoin College Museum of Art, Brunswick, Maine
Brandeis University Rose Art Museum, Waltham, Massachusetts
The Brooklyn Museum, Brooklyn, New York
The Cleveland Museum of Art, Cleveland, Ohio
Hallmark Photographic Collection, Kansas City, Missouri
International Museum of Photography at George Eastman House,
 Rochester, New York
The Israel Museum, Jerusalem, Israel
List Visual Arts Center, Massachusetts Institute of Technology,
 Cambridge, Massachusetts
The Metropolitan Museum of Art, New York, New York
Middlebury College Museum of Art, Middlebury, Vermont
Milwaukee Art Museum, Milwaukee, Wisconsin
The Museum of Contemporary Photography, Chicago, Illinois
Museum of Fine Arts, Boston, Massachusetts
The Museum of Fine Arts, Houston, Texas
The Museum of Modern Art, New York, New York
Museum of Photographic Arts, San Diego, California
National Gallery of Art, Washington, D.C.
The New Orleans Museum of Art, New Orleans, Louisiana
The New York Public Library, New York, New York
The Saint Louis Art Museum, Saint Louis, Missouri
San Francisco Museum of Modern Art, San Francisco, California
Yale University Art Gallery, New Haven, Connecticut

ABOUT THE AUTHORS

Charles Simic is a poet who has also written essays on various aspects of modernist poetics and has translated contemporary Yugoslav poetry. His works include: *Walking the Black Cat* (1996), *A Wedding in Hell* (1994), *Hotel Insomnia* (1992), *The Book of Gods and Devils* (1990), *Selected Poems 1963–1983* (1985), *Charon's Cosmology* (1977), and *Dismantling the Silence* (1971). Although born in Yugoslavia, Simic views himself as a New England writer working in the traditions of Emily Dickinson and Nathaniel Hawthorne. He teaches American literature and creative writing at the University of New Hampshire. Simic has received numerous literary awards, including a Guggenheim Fellowship, P.E.N. Translation Prize, MacArthur Fellowship, and Pulitzer Prize.

Jennifer R. Gross is currently curator of contemporary art and public programs at the Isabella Stewart Gardner Museum in Boston. Gross came to the Gardner Museum from the Institute of Contemporary Art at the Maine College of Art in Portland, Maine, where she was director. During her tenure as director, Gross oversaw the design and construction of the ICA@MECA's new galleries and curated exhibitions by such artists as Peter Campus, Maureen Connor, John Coplans, David Ireland, Matthew McCaslin, Beverly Semmes, and Jessica Stockholder and inaugurated the ICA@MECA galleries with "Quiet in the Land: Everyday Life, Contemporary Art, and the Shakers," curated by France Morin.

While at the Maine College of Art, Gross was assistant professor, lecturing in critical theory and contemporary art. Previous to her experience in Maine, Gross was director of the Germans van Eck Gallery in New York, New York, which specialized in presenting the work of young and mid-career American and international contemporary artists. Gross obtained a B.A. degree from Lafayette College, Easton, Pennsylvania, in international affairs, an M.A. in art history from Hunter College, New York, New York; and is currently a doctoral candidate at the City University of New York, Graduate Center. The subject of her dissertation is the American artist Richard Tuttle.